The mind's eye

The mind's eye

Writings on Photography and Photographers

Henri Cartier-Bresson

APERTURE

IN A WORLD that is buckling under the weight of profit-making, that is overrun by the destructive sirens of Techno-science and the power-hunger of globalization—that new brand of slavery—beyond all that, Friendship exists, Love exists.

1998

Dans un monde qui s'
écroule sous le poids de
la rentabilité, envahi par
les sirènes ravageuses de
la Techno-science, la
voracité du pouvoir —
par la mondialisation —
nouvel esclavage — au delà
de tout cela, l'Amitié, l'Amour
existent.

Henri Cartier-Bresson
15.5.98

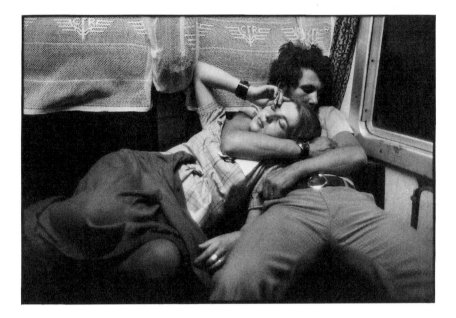

Romania, 1975

THE LIGHTEST BAGGAGE
by Gérard Macé

———

Henri Cartier-Bresson has traveled everywhere, carrying the lightest baggage.

In saying that, I am referring not only to the famous Leica, the portable magic camera that has enabled him to be an invisible man amid crowds, and to run like a shot as far as he could from the academic institutions where you learn perspective by tracing out lines—so that he could crisscross Europe in the company of André Pieyre de Mandiargues; and later Asia, where events were there for the finding, where street scenes offered themselves to him as if the entire world had become his personal open-air studio.

Certainly, the Impressionists before him propped their easels by riverbanks, or on meadows where the light came down like the dew, but their world was like an endless Sunday, whereas photography lets us have a look at the working days. And then, his passion for painting notwithstanding, one can't really imagine Henri Cartier-Bresson chained to an easel for his whole life, spending entire hours in front of a landscape, bothered by curious onlookers, annoyed by wasps, and winding up posing for a photographer looking for

clichés. That pose is too serious, the materials too heavy, for this Buddhist in flux.

The lightest baggage is that old lesson which can't be learned, but which accompanies us everywhere once we understand it; it has enabled Henri Cartier-Bresson to remove himself as a person, to disappear in order to capture the instant, giving it a sense of instantaneity; to see Alberto Giacometti walking with the same step as his own statues, and Faulkner in his shirtsleeves, capturing the imagination; to see the shape of destiny in the clouds and smoke of India, in a peacock fanning its tail. . . . This is the lesson of the Old Masters, which has allowed him to bring the Golden Section into the darkroom, and to illustrate (without realizing it) Delacroix's notion of the "drawing machine," which can correct both the eye's mistakes and gaps in teaching: "The daguerreotype is more than just a copy: it is the mirror of the object; certain details—nearly all of which are neglected in drawing from nature—here take on a characteristic importance, and thus introduce the artist into the complete understanding of its construction: the shadows and lights appear with their precise degrees of firmness or of softness— an extremely subtle distinction without which there can be no sense of projection."

To return to drawing, as Henri Cartier-Bresson has done in recent years, is thus to shatter the mirror and see

with the naked eye—that is, to accept the incorrectness of the world, and our own imperfection.

To meditate on the jumble of appearances, rather than continuing in the oblivion that photography sometimes is, was, in the end, for this rebellious personality, to rediscover a kind of liberty.

The Henri Cartier-Bresson style can be found, whole and intact, in his writing—whether testimony, caption, or dedication: it is always a concise work of art, an improvisation that succeeds because of his nearly infallible sense of phrasing (for example, this sentence caught in midair after he had been listening to one of Johann Sebastian Bach's cello suites: "That is music to dance to, just before dying"); it presumes the same sense of the decisive moment that he has in photography—even if the retouches and the reworkings make for less waste in this other medium.

It is thanks to Tériade, who showed him the art of the book and who was the unforgettable publisher of *Images à la Sauvette* [*The Decisive Moment*], that Henri Cartier-Bresson discovered this extra gift, by writing that book's preface, which was to become an important reference for photographers, but which also deserves to be read in a less restrictive way—as a poetic art form unto itself. In the same way that one should read his intense reactions, his discreet but precise

memories, filled with humor and affection, about Jean Renoir; and his unbiased testimonies—about Cuba, for example, where he saw more clearly than anyone in the early stages of Castro's regime, more clearly, at any rate, than many writers on assignment there.

Henri Cartier-Bresson writes in India ink—no doubt because it is an ink that can't be watered down. And now, thanks to the fax, which is to writing what the Leica was to photography, there is no delay at all. Because there are certain machines that he doesn't loathe, so long as they are lightweight and go fast—in other words, if they allow him to grasp the instant.

To aim accurately is another matter: the eyes are not enough; you sometimes have to hold your breath. But we know that Henri Cartier-Bresson, along with being a geometrician without a sliderule, is a sharpshooter.

1996

I

The Camera
As Sketchbook

THE MIND'S EYE

———

Photography has not changed since its origin except in its technical aspects, which for me are not a major concern.

Photography appears to be an easy activity; in fact it is a varied and ambiguous process in which the only common denominator among its practitioners is their instrument. What emerges from this recording machine does not escape the economic constraints of a world of waste, of tensions that become increasingly intense, and of insane ecological consequences.

"Manufactured" or staged photography does not concern me. And if I make a judgement it can only be on a psychological or sociological level. There are those who take photographs arranged beforehand and those who go out to discover the image and seize it. For me the camera is a sketch book, an instrument of intuition and spontaneity, the master of the instant which, in visual terms, questions and decides simultaneously. In order to "give a meaning" to the world, one has to feel oneself involved in what one frames through the viewfinder. This attitude requires concentration, a discipline of mind, sensitivity, and a sense of geometry—it is by

great economy of means that one arrives at simplicity of expression. One must always take photographs with the greatest respect for the subject and for oneself.

To take photographs is to hold one's breath when all faculties converge in the face of fleeing reality. It is at that moment that mastering an image becomes a great physical and intellectual joy.

To take photographs means to recognize—simultaneously and within a fraction of a second—both the fact itself and the rigorous organization of visually perceived forms that give it meaning. It is putting one's head, one's eye, and one's heart on the same axis.

As far as I am concerned, taking photographs is a means of understanding which cannot be separated from other means of visual expression. It is a way of shouting, of freeing oneself, not of proving or asserting one's originality. It is a way a life.

Anarchy is an ethic.

Buddhism is neither a religion nor a philosophy, but a medium that consists in controlling the spirit in order to attain harmony and, through compassion, to offer it to others.

1976

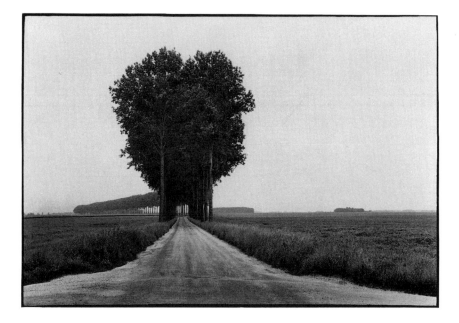

In Brie, France, June 1968

Ma passion n'a jamais été pour
la photographie "en elle même",
mais pour la possibilité, en s'
oubliant soi-même, d'enregistrer
dans une fraction de seconde
l'émotion procurée par le sujet
et la beauté de la forme,
c'est a dire une géométrie
éveillée par ce qui est offert. —

Le tir photographique est
un de mes carnets de croquis.

8.2.94

MY PASSION has never been for photography "in itself," but for the possibility—through forgetting yourself—of recording in a fraction of a second the emotion of the subject, and the beauty of the form; that is, a geometry awakened by what's offered.

The photographic shot is one of my sketchpads.

1994

THE DECISIVE MOMENT

"There is nothing in this world without a decisive moment."
—Cardinal Retz

I, like many another boy, burst into the world of photography with a Box Brownie, which I used for taking holiday snapshots. Even as a child, I had a passion for painting, which I "did" on Thursdays and Sundays, the days when French school children don't have to go to school. Gradually, I set myself to try to discover the various ways in which I could play with a camera. From the moment that I began to use the camera and to think about it, however, there was an end to holiday snaps and silly pictures of my friends. I became serious. I was on the scent of something, and I was busy smelling it out.

Then there were the movies. From some of the great films, I learned to look, and to see. *Mysteries of New York*, with Pearl White; the great films of D. W. Griffith—*Broken Blossoms*; the first films of Stroheim; *Greed*; Eisenstein's *Potemkin*; and Dreyer's *Jeanne d'Arc*—these were some of the things that impressed me deeply.

Later I met photographers who had some of Atget's prints. These I considered remarkable and, accordingly, I bought myself a tripod, a black cloth, and a polished walnut camera three by four inches. The camera was fitted with—instead of a shutter—a lenscap, which one took off and then put on to make the exposure. This last detail, of course, confined my challenge to the static world. Other photographic subjects seemed to me to be too complicated, or else to be "amateur stuff." And by this time I fancied that by disregarding them, I was dedicating myself to Art with a capital "A."

Next I took to developing this Art of mine in my washbasin. I found the business of being a photographic Jack-of-All-Trades quite entertaining. I knew nothing about printing, and had no inkling that certain kinds of paper produced soft prints and certain others highly contrasted ones. I didn't bother much about such things, though I invariably got mad when the images didn't come out right on the paper.

In 1931, when I was twenty-two, I went to Africa. On the Ivory Coast I bought a miniature camera of a kind I have never seen before or since, made by the French firm Krauss. It used film of a size that 35mm would be without the sprocket holes. For a year I took pictures with it. On my return to France I had my pictures developed—it was not

possible before, for I lived in the bush, isolated, during most of that year—and I discovered that the damp had got into the camera and that all my photographs were embellished with the superimposed patterns of giant ferns.

I had had blackwater fever in Africa, and was now obliged to convalesce. I went to Marseille. A small allowance enabled me to get along, and I worked with enjoyment. I had just discovered the Leica. It became the extension of my eye, and I have never been separated from it since I found it. I prowled the streets all day, feeling very strung-up and ready to pounce, determined to "trap" life—to preserve life in the act of living. Above all, I craved to seize, in the confines of one single photograph, the whole essence of some situation that was in the process of unrolling itself before my eyes.

The idea of making a photographic reportage, that is to say, of telling a story in a sequence of pictures, never entered my head at that time. I began to understand more about it later, as a result of looking at the work of my colleagues and at the illustrated magazines. In fact, it was only in the process of working for them that I eventually learned, bit by bit, how to make a reportage with a camera, how to make a picture-story.

I have traveled a good deal, though I don't really know how to travel. I like to take my time about it, leaving between one country and the next an interval in which to

digest what I've seen. Once I have arrived in a new country, I feel almost like settling down there, so as to live on proper terms with the country. I could never be a globetrotter.

In 1947, five freelance photographers, of whom I was one, founded our cooperative enterprise called "Magnum Photos." This cooperative enterprise distributes our picture-stories to magazines in various countries.

Twenty-five years have passed since I started to look through my view-finder. But I regard myself still as an amateur, though I am no longer a dilettante.

The Picture Story

What actually *is* a photographic reportage, a picture story? Sometimes there is one unique picture whose composition possesses such vigor and richness, and whose content so radiates outward from it, that this single picture is a whole story in itself. But this rarely happens. The elements which, together, can strike sparks from a subject, are often scattered— either in terms of space or time—and bringing them together by force is "stage management," and, I feel, cheating. But if it is possible to make pictures of the "core" as well as the struck-off sparks of the subject, this is a picture-story. The page serves to reunite the complementary elements which are dispersed throughout several photographs.

The picture-story involves a joint operation of the brain, the eye, and the heart. The objective of this joint operation is to depict the content of some event which is in the process of unfolding, and to communicate impressions. Sometimes a single event can be so rich in itself and its facets that it is necessary to move all around it in your search for the solution to the problems it poses—for the world is movement, and you cannot be stationary in your attitude toward something that is moving. Sometimes you light upon the picture in seconds; it might also require hours or days. But there is no standard plan, no pattern from which to work. You must be on the alert with the brain, the eye, the heart, and have a suppleness of body.

Things-As-They-Are offer such an abundance of material that a photographer must guard against the temptation of trying to do everything. It is essential to cut from the raw material of life—to cut and cut, but to cut with discrimination. While working, a photographer must reach a precise awareness of what he is trying to do. Sometimes you have the feeling that you have already taken the strongest possible picture of a particular situation or scene; nevertheless, you find yourself compulsively shooting, because you cannot be sure in advance exactly how the situation, the scene, is going to unfold. You must stay with the scene, just in case the elements of the situation shoot off from the core again. At the

same time, it's essential to avoid shooting like a machine-gunner and burdening yourself with useless recordings which clutter your memory and spoil the exactness of the reportage as a whole.

Memory is very important, particularly in respect to the recollection of every picture you've taken while you've been galloping at the speed of the scene itself. The photographer must make sure, while he is still in the presence of the unfolding scene, that he hasn't left any gaps, that he has really given expression to the meaning of the scene in its entirety, for afterward it is too late. He is never able to wind the scene backward in order to photograph it all over again.

For photographers, there are two kinds of selection to be made, and either of them can lead to eventual regrets. There is the selection we make when we look through the view-finder at the subject; and there is the one we make after the films have been developed and printed. After developing and printing, you must go about separating the pictures which, though they are all right, aren't the strongest. When it's too late, then you know with a terrible clarity exactly where you failed; and at this point you often recall the telltale feeling you had while you were actually making the pictures. Was it a feeling of hesitation due to uncertainty? Was it because of some physical gulf between yourself and the unfolding event? Was it simply that you did not take into

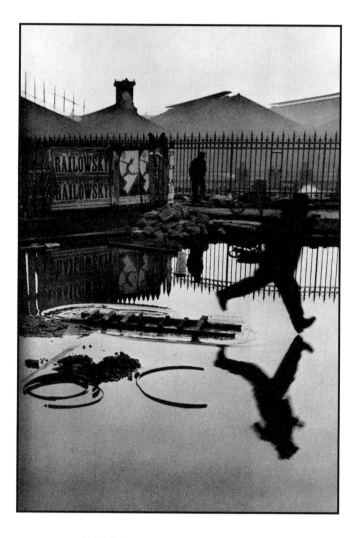

Behind the Saint-Lazare station, Paris, 1932

account a certain detail in relation to the whole setup? Or was it (and this is more frequent) that your glance became vague, your eye wandered off?

For each of us space begins and slants off from our own eye, and from there enlarges itself progressively toward infinity. Space, in the present, strikes us with greater or lesser intensity and then leaves us, visually, to be closed in our memory and to modify itself there. Of all the means of expression, photography is the only one that fixes forever the precise and transitory instant. We photographers deal in things that are continually vanishing, and when they have vanished, there is no contrivance on earth that can make them come back again. We cannot develop and print a memory. The writer has time to reflect. He can accept and reject, accept again; and before committing his thoughts to paper he is able to tie the several relevant elements together. There is also a period when his brain "forgets," and his subconscious works on classifying his thoughts. But for photographers, what has gone is gone forever. From that fact stem the anxieties and strength of our profession. We cannot do our story over again once we've got back to the hotel. Our task is to perceive reality, almost simultaneously recording it in the sketchbook which is our camera. We must neither try to manipulate reality while we are shooting, nor manipulate the results in a darkroom. These tricks are patently discernible to those who have eyes to see.

In shooting a picture-story we must count the points and the rounds, rather like a boxing referee. In whatever picture-story we try to do, we are bound to arrive as intruders. It is essential, therefore, to approach the subject on tiptoe—even if the subject is still-life. A velvet hand, a hawk's eye—these we should all have. It's no good jostling or elbowing. And no photographs taken with the aid of flashlight either, if only out of respect of the actual light—even when there isn't any of it. Unless a photographer observes such conditions as these, he may become an intolerably aggressive character.

The profession depends so much upon the relations the photographer establishes with the people he's photographing, that a false relationship, a wrong word or attitude, can ruin everything. When the subject is in any way uneasy, the personality goes away where the camera can't reach it. There are no systems, for each case is individual and demands that we be unobtrusive, though we must be at close range. Reactions of people differ much from country to country, and from one social group to another. Throughout the whole of the Orient, for example, an impatient photographer—or one who is simply pressed for time—is subject to ridicule. If you have made yourself obvious, even just by getting your light-meter out, the only thing to do is to forget about photography for the moment, and accom-

modatingly allow the children who come rushing at you to cling to your knees like burrs.

The Subject

There is subject in all that takes place in the world, as well as in our personal universe. We cannot negate subject. It is everywhere. So we must be lucid toward what is going on in the world, and honest about what we feel.

Subject does not consist of a collection of facts, for facts in themselves offer little interest. Through facts, however, we can reach an understanding of the laws that govern them, and be better able to select the essential ones which communicate reality.

In photography, the smallest thing can be a great subject. The little, human detail can become a leitmotiv. We see and show the world around us, but it is an event itself which provokes the organic rhythm of forms.

There are thousands of ways to distill the essence of something that captivates us; let's not catalogue them. We will, instead, leave it in all its freshness....

There is a whole territory which is no longer exploited by painting. Some say it is because of the discovery of photography. However it came about, photography has taken over a part of this territory in the form of illustration.

One kind of subject matter greatly derided by present-day painters is the portrait. The frock coat, the soldier's cap, the horse now repel even the most academic of painters. They feel suffocated by all the gaiter buttons of the Victorian portrait makers. For photographers—perhaps because we are reaching for something much less lasting in value than the painters—this is not so much irritating as amusing, because we accept life in all its reality.

People have an urge to perpetuate themselves by means of a portrait, and they put their best profiles forward for posterity. Mingled with this urge, though, is a certain fear of black magic; a feeling that by sitting for a camera portrait they are exposing themselves to the workings of witchcraft of a sort.

One of the fascinating things about portraits is the way they enable us to trace the sameness of man. Man's continuity somehow comes through all the external things that constitute him—even if it is only to the extent of someone's mistaking Uncle for Little Nephew in the family album. If the photographer is to have a chance of achieving a true reflection of a person's world—which is as much outside him as inside him—it is necessary that the subject of the portrait should be in a situation normal to him. We must respect the atmosphere which surrounds the human being, and integrate into the portrait the individual's habitat—for

man, no less than animals, has his habitat. Above all, the sitter must be made to forget about the camera and the photographer who is handling it. Complicated equipment and light reflectors and various other items of hardware are enough, to my mind, to prevent the birdie from coming out.

What is there more fugitive and transitory than the expression on a human face? The first impression given by a particular face is often the right one; but the photographer should try always to substantiate the first impression by "living" with the person concerned. The decisive moment and psychology, no less than camera position, are the principal factors in the making of a good portrait. It seems to me it would be pretty difficult to be a portrait photographer for customers who order and pay since, apart from a Maecenas or two, they want to be flattered, and the result is no longer real. The sitter is suspicious of the objectivity of the camera, while the photographer is after an acute psychological study of the sitter.

It is true, too, that a certain identity is manifest in all the portraits taken by one photographer. The photographer is searching for identity of his sitter, and also trying to fulfill an expression of himself. The true portrait emphasizes neither the suave nor the grotesque, but reflects the personality.

I infinitely prefer, to contrived portraits, those little identity-card photos which are pasted side by side, row after

row, in the windows of passport photographers. At least there is on these faces something that raises a question, a simple factual testimony—this in place of the poetic identification we look for.

Composition

If a photograph is to communicate its subject in all its intensity, the relationship of form must be rigorously established. Photography implies the recognition of a rhythm in the world of real things. What the eye does is to find and focus on the particular subject within the mass of reality; what the camera does is simply to register upon film the decision made by the eye. We look at and perceive a photograph, as we do a painting, in its entirety and all in one glance. In a photograph, composition is the result of a simultaneous coalition, the organic coordination of elements seen by the eye. One does not add composition as though it were an afterthought superimposed on the basic subject material, since it is impossible to separate content from form. Composition must have its own inevitability about it.

In photography there is a new kind of plasticity, the product of instantaneous lines made by movements of the subject. We work in unison with movement as though it were a presentiment of the way in which life itself unfolds.

But inside movement there is one moment at which the elements in motion are in balance. Photography must seize upon this moment and hold immobile the equilibrium of it.

The photographer's eye is perpetually evaluating. A photographer can bring coincidence of line simply by moving his head a fraction of a millimeter. He can modify perspectives by a slight bending of the knees. By placing the camera closer to or farther from the subject, he draws a detail—and it can be subordinated, or he can be tyrannized by it. But he composes a picture in very nearly the same amount of time it takes to click the shutter, at the speed of a reflex action.

Sometimes it happens that you stall, delay, wait for something to happen. Sometimes you have the feeling that here are all the makings of a picture—except for just one thing that seems to be missing. But what one thing? Perhaps someone suddenly walks into your range of view. You follow his progress through the viewfinder. You wait and wait, and then finally you press the button—and you depart with the feeling (though you don't know why) that you've really got something. Later, to substantiate this, you can take a print of this picture, trace on it the geometric figures which come up under analysis, and you'll observe that, if the shutter was released at the decisive moment, you have instinctively fixed a geometric pattern without which the photograph would have been both formless and lifeless.

Composition must be one of our constant preoccupations, but at the moment of shooting it can stem only from our intuition, for we are out to capture the fugitive moment, and all the interrelationships involved are on the move. In applying the Golden Rule, the only pair of compasses at the photographer's disposal is his own pair of eyes. Any geometrical analysis, any reducing of the picture to a schema, can be done only (because of its very nature) after the photograph has been taken, developed, and printed—and then it can be used only for a post-mortem examination of the picture. I hope we will never see the day when photo shops sell little schema grills to clamp onto our viewfinders; and the Golden Rule will never be found etched on our ground glass.

If you start cutting or cropping a good photograph, it means death to the geometrically correct interplay of proportions. Besides, it very rarely happens that a photograph which was feebly composed can be saved by reconstruction of its composition under the darkroom's enlarger; the integrity of vision is no longer there. There is a lot of talk about camera angles; but the only valid angles in existence are the angles of the geometry of composition and not the ones fabricated by the photographer who falls flat on his stomach or performs other antics to procure his effects.

———

Color

In talking about composition we have been so far thinking only in terms of that symbolic color called black. Black-and-white photography is a deformation, that is to say, an abstraction. In it, all the values are transposed; and this leaves the possibility of choice.

Color photography brings with it a number of problems that are hard to resolve today, and some of which are difficult even to foresee, owing to its complexity and its relative immaturity. At present [1952], color film emulsions are still very slow. Consequently, photographers using color have a tendency to confine themselves to static subjects; or else to use ferociously strong artificial lights. The slow speed of color film reduces the depth of focus in the field of vision in relatively close shots; and this cramping often makes for dull composition. On top of that, blurred backgrounds in color photographs are distinctly displeasing.

Color photographs in the form of transparencies seem quite pleasing sometimes. But then the engraver takes over; and a complete understanding with the engraver would appear to be as desirable in this business as it is in lithography. Finally, there are the inks and the paper, both of which are capable of acting capriciously. A color photograph repro-

duced in a magazine or semi-luxury edition sometimes gives the impression of an anatomical dissection which has been badly bungled.

It is true that color reproductions of pictures and documents have already achieved a certain fidelity to the original; but when the color proceeds to take on real life, it's another matter. We are only in the infancy of color photography. But all this is not to say we should take no further interest in the question, or sit by waiting for the perfect color film— packaged with the talent necessary to use it—to drop into our laps. We must continue to try to feel our way.

Though it is difficult to foresee exactly how color photography is going to grow in photo-reporting, it seems certain that it requires a new attitude of mind, an approach different than that which is appropriate for black-and-white. Personally, I am half afraid that this complex new element may tend to prejudice the achievement of the life and movement which is often caught by black-and-white.

To really be able to create in the field of color photography, we should transform and modulate colors, and thus achieve liberty of expression within the framework of the laws which were codified by the Impressionists and from which even a photographer cannot shy away. (The law, for instance, of simultaneous contrast: the law that every color tends to tinge the space next to it with its complementary

color; that if two tones contain a color which is common to them both, that common color is attenuated by placing the two tones side by side; that two complementary colors placed side by side emphasize both, but mixed together they annihilate each other; and so on.)

The operation of bringing the color of nature in space to a printed surface poses a series of extremely complex problems. To the eye, certain colors advance, others recede. So we would have to be able to adjust the relations of the color one to the other, for colors, which in nature place themselves in the depth of space, claim a different placing on a plane surface—whether it is the flat surface of a painting or a photograph.

The difficulties involved in snapshooting are precisely that we cannot control the movement of the subject; and in color-photography reporting, the real difficulty is that we are unable to control the interrelation of colors within the subject. It wouldn't be hard to add to the list of difficulties involved, but it is quite certain that the development of photography is tied up with the development of its technique.

Technique
———

Constant new discoveries in chemistry and optics are widening our field of action considerably. It is up to us to

apply them to our technique, to improve ourselves, but there is a whole group of fetishes which have developed on the subject of technique.

Technique is important only insofar as you must master it in order to communicate what you see. Your own personal technique has to be created and adapted solely in order to make your vision effective on film. But only the results count, and the conclusive evidence is the finished photographic print; otherwise there would be no end to the number of tales photographers would tell about pictures which they ever-so-nearly got—but which are merely a memory in the eye of the nostalgia.

Our trade of photo-reporting has been in existence only about thirty years. It came to maturity due to the development of easily handled cameras, faster lenses, and fast fine-grain films produced for the movie industry. The camera is for us a tool, not a pretty mechanical toy. In the precise functioning of the mechanical object perhaps there is an unconscious compensation for the anxieties and uncertainties of daily endeavor. In any case, people think far too much about techniques and not enough about seeing.

It is enough if a photographer feels at ease with his camera, and if it is appropriate to the job he wants it to do. The actual handling of the camera, its stops, its exposure-speeds and all the rest of it are things which should be as automatic

as the changing of gears in an automobile. It is no part of my business to go into the details or refinements of any of these operations, even the most complicated ones, for they are all set forth with military precision in the manuals which the manufacturers provide along with the camera and the nice orange calf-skin case. If the camera is a beautiful gadget, we should progress beyond that stage at least in conversation. The same applies to the hows and whys of making pretty prints in the darkroom.

During the process of enlarging, it is essential to re-create the values and mood of the time the picture was taken; or even to modify the print so as to bring it into line with the intentions of the photographer at the moment he shot it. It is necessary also to re-establish the balance which the eye is continually establishing between light and shadow. And it is for these reasons that the final act of creating in photography takes place in the darkroom.

I am constantly amused by the notion that some people have about photographic technique—a notion which reveals itself in an insatiable craving for sharpness of images. Is this the passion of an obsession? Or do these people hope, by this *trompe l'oeil* technique, to get to closer grips with reality? In either case, they are just as far away from the real problem as those of that other generation which used to endow all its photographic anecdotes with an intentional unsharpness such as was deemed to be "artistic."

The Customers

The camera enables us to keep a sort of visual chronicle. For me, it is my diary. We photo-reporters are people who supply information to a world in a hurry, a world weighted down with preoccupations, prone to cacophony, and full of beings with a hunger for information and needing the companionship of images. We photographers, in the course of taking pictures, inevitably make a judgement on what we see, and that implies a great responsibility. We are, however, dependent on printing, since it is to the illustrated magazines that we, as artisans, deliver raw material.

It was indeed an emotional experience for me when I sold my first photograph (to the French magazine *Vu*). That was the start of a long alliance with magazines. The magazines produce for us a public, and introduce us to that public; and they know how to get picture-stories across in the way the photographer intended. But sometimes, unhappily, they distort them. The magazine can publish exactly what the photographer wanted to show; but the photographer runs the risk of letting himself be molded by the taste or the requirements of the magazine.

In a picture-story, the captions should invest the pictures with a verbal context, and should illuminate whatever relevant thing it may have been beyond the power of camera to reach.

Unfortunately, in the sub-editor's room, mistakes sometimes slip in that are not just simple misspellings or malapropisms. For these mistakes the reader often holds the photographer responsible. Such things do happen.

The pictures pass through the hands of the editor and the layout man. The editor has to make his choice from the thirty or so pictures of which the average picture-story consists. (It is rather as though he had to cut a text article to pieces in order to end up with a series of quotations!) For a picture-story, as for a novel, there are certain set forms. The pictures of the editor's choice have to be laid out within the space of two, three, or four pages, according to the amount of interest he thinks they are likely to arouse, or according to the current state of paper shortage.

The great art of the layout man lies in his knowing how to pick from this pile of pictures the particular one which deserves a full-page or a double-page spread; in his knowing where to insert the small picture which must serve as an indispensable link in the story. (The photographer, when he is actually taking the pictures for his story, should never give a thought to the ways in which it will be possible to lay out those pictures to the most advantage.) The layout man will often have to crop one picture so as to leave only the most important section of it—since, for him, it is the unity of the whole page or of the whole spread that counts above all else. A photographer can

scarcely be too appreciative of the layout man who gives his work a beautiful presentation of a kind which keeps the full import of the story; a display in which the pictures have spatially correct margins and stand out as they should; and in which each page possesses its own architecture and rhythm.

There is a third anguish for a photographer—when he looks for his story in a magazine.

There are ways of communicating our photographs other than through publication in magazines. Exhibitions, for instance; and the book form, which is almost a form of permanent exhibition.

I have talked at some length, but of only one kind of photography. There are many kinds. Certainly the fading snapshot carried in the back of a wallet, the glossy advertising catalog, and the great range of things in between are photography. I don't attempt to define it for everyone. I only attempt to define it to myself:

To me, photography is the simultaneous recognition, in a fraction of a second, of the significance of an event as well as of a precise organization of forms which give that event its proper expression.

I believe that, through the act of living, the discovery of oneself is made concurrently with the discovery of the world around us, which can mold us, but which can also be affected by us. A balance must be established between these two worlds—the one inside us and the one outside us. As the result of a constant recip-

rocal process, both these worlds come to form a single one. And it is this world that we must communicate.

But this takes care only of the content of the picture. For me, content cannot be separated from form. By form, I mean a rigorous organization of the interplay of surfaces, lines, and values. It is in this organization alone that our conceptions and emotions become concrete and communicable. In photography, visual organization can stem only from a developed instinct.

1952

PHOTOGRAPHY AND COLOR

(Postscript)

Color, in photography, is founded on a basic prism; for the time being, it cannot be otherwise, because we do not yet have the chemical processes that permit the complex breaking down and reconstitution of color (in the pastel range, for example, the gamut of greens is made up of 375 nuances!).

For me, color is a very important medium of information, but it is very limited on the reproduction-surface, which remains chemical and not transcendental, not intuitive, as it is in painting. As opposed to black, which has the most complex range, color, on the contrary, offers only a fragmentary range.

1985

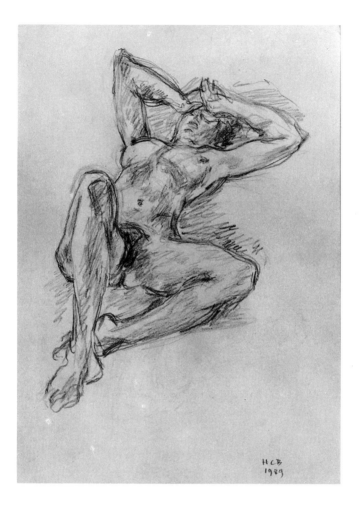

Nude, 1989

PHOTOGRAPHY AND DRAWING:
A Parallel

———

Photography is, for me, a spontaneous impulse coming from an ever-attentive eye, which captures the moment and its eternity.

Drawing, with its graphology, elaborates what our consciousness grasps in an instant.

Movies tell a story visually.

Photography is an immediate reaction, drawing a meditation.

THE DEBATE over the place and rank we should confer to photography among the plastic arts has never concerned me, because this problem of hierarchy has always seemed to me purely academic in essence.

1985

Le débat sur le grade
et la place que l'on
devrait conférer a la
photographie parmi
les arts plastiques ne
m'a jamais préoccupé,
car ce problème de
hiérarchie m'a toujours
semblé d'essence
purement academique.

27.11.85

II

Time and Place

EUROPEANS

One day, I met a Scotsman: "They say you've traveled through many countries. How is it that you haven't made a single photograph of Scotland?" I had trouble convincing him that there wasn't some discrimination at work against his country. On the contrary, and without having to go all the way back to Mary Stuart, there are links between France and Scotland....

Plainly, there is a *flâneur* side to the photographer, and if he is gifted with a methodical mind, he can use it to put together a sort of repertoire, or directory: "What are you talking about? What do you mean?" our Scotsman asked.

In *War and Peace*, Tolstoy says: "I see that however much and however carefully I were to observe the hands of my watch, and the valves and wheels of the locomotive, the buds of the oak, I still wouldn't understand the cause of the bells ringing, the motion of the locomotive, or the spring breeze.

"To reach such an understanding, I would have to change my point of view completely, study the laws of movement, of steam, of bells, and of wind. History must do the same thing. And attempts in this direction have already been made." (Book III, chapter 1).

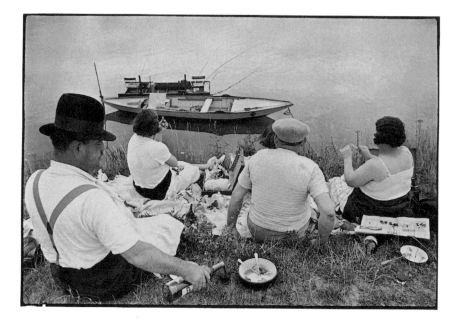

By the Marne River, 1938

The photographer can merely show the clock's hands, but he does choose his moments. "I was there, and this is what life was at the moment that I saw it." These people who actually participate in life—these Europeans—might at first glance all look alike, to a Hottentot, say, or a Chinese peasant; but if one were to compare our lands, square mile for square mile, it would probably be here that one would find the greatest number of differences in historical and geographical origins. Our need for joy and good will, and our savageness too, are manifested through minute and infinitely numerous details. These details strike us with their novelty, but also with their familiarity, almost like memories. We feel we recognize them amid our general impressions—a bit like being in a museum for the first time, but a museum in which we know certain paintings from reproductions. Finding ourselves face-to-face with one of these paintings, we experience the shock of surprise, and also the joy of sizing it up for an actual confrontation.

In photography, creation is a quick business—an instant, a gush, a response—putting the camera up to the eye's line of fire, snatching with that economical little box whatever it was that surprised you, catching it in midair, without tricks, without letting it get away. You make a painting at the same time that you take a photo.

That moment, that fraction of a second, is valuable for the freshness of its impression—but does it preclude a more

studied experience? Is it possible to find that same freshness if you stay for a long time in one spot? Whether you are on the move or in one place, in order to show a country or a situation, somehow you need to have established close working relationships, to be supported by a human community; living takes time, roots form slowly. Thus that fraction of a moment can be the fruit of a long acquaintance, or one of surprise.

There was a time when the world's geography was illustrated through reproductions of great monuments or images of ethnic types; today, that picture has been revamped by the addition of human elements provided by photography. When dropping a stone into a well, one never knows what the echo will be; when you send a photograph into circulation, it is out of your hands. The world's lesson in photography might have happy or disastrous results, depending on the little fact of whether it is shown to be isolated, detached or not, from its contexts of time, place, humanity.

Like people, countries are not all the same age, nor do they have the same destiny; the degree of their maturity differs depending on what element is in question. Sometimes also, even in the most radically transformed places, traits show up that you'd have thought had disappeared—as if you

were recognizing a young girl, having only seen a portrait of her long-dead grandmother.

All too often, tourists get lost in comparisons with their own country, dragging their references into personal opinions or memories. "Really, *how* could one live in Persia?"

Culture shock is often felt sharply at the borders between countries, but sometimes it doesn't hit fully until you've been in a place for a long time.

Of course, I'm not talking about the universal reign of the man-in-the-suit, nor of the worldwide standardization of objects, but of people with their joys, their pains, their struggles.

There are a thousand ways of describing it, but it will never be possible for me to say that "the characters in this book are entirely fictional," and that "any resemblance to real people is purely coincidental."

1955

FROM ONE CHINA
TO THE OTHER

———

In early December of 1948 I took a plane to Rangoon, in Burma, and went from there to China. I had been in Beijing for twelve days when the city was taken by Mao Zedong's armies, and I left the capital on the very last plane, which had to take off in a vertical spiral, because the Communists had begun to surround the airport.

Once I'd arrived in Shanghai, I looked for a way to get into the zones that were controlled by the People's Army. They were all blocked, but I managed to get to Hong Kong on the British sloop *The Amethyst*, and to ask Huang Hua, representative of the People's Republic in Hong Kong (and future Minister of Foreign Affairs), for a pass to Beijing. He told me extremely politely that as he was neither a travel agent nor a consulate (etc.), he could only send an underground letter to facilitate this for me.

To cross the border, I chose the region of Qingdao, in the Shandong peninsula, in the north. I'd heard that missionaries were having little trouble using this route to join up with their followers. Why not follow their example, load my bags onto a cart and push it in front of me as they did?

I was just about to leave when I met two Americans, a journalist and a businessman, who wanted to take the same route, but in a jeep. Leaving the Guomindang soldiers behind us, the three of us set off toward adventure. There was a terrible snowstorm, and we could barely distinguish the roads from the fields. After some time in this no-man's-land, we glimpsed shadows moving about in the surrounding landscape, between the rises of tombs. I got out and walked in front of the jeep, waving a white handkerchief at the end of a stick and my French passport, which we considered our best safeguards in that white and disturbing solitude.

After twelve kilometers of this, we reached a village where a detachment of the People's Army was billeted. The young commissar of the detachment was the only one who spoke English—he had cousins in San Francisco, London, Hong Kong, etc. He thought our expedition imprudent, and asked for instructions from higher up. In the meantime, they put us up in a farm where we slept by the stove, and it was very interesting to observe the life of the villagers and of the "Pai Loo" (the sixth battalion). After five weeks, they asked us to go back where we came from. If I've narrated this escapade in some detail, it's because I was obviously unable to bring back any photographs and so this story is my only journal.

I returned to find Shanghai in complete disorder. I left the city to accompany some Buddhists who were going

on a pilgrimage for peace to the sanctuaries of Hangzhou. I learned that the front was quickly approaching the Chang River.

I hurried to Nanjing, capital of the Guomindang. At that point it was every man for himself, and you often saw entire families crammed into rickshaws with bundles of their belongings. The Communist troops would be crossing the Chang any day now, you could feel it in the air.

Life magazine, knowing that I had been to Hong Kong on the British ship *The Amethyst* (which was then anchored on the Chang), cabled me to see if I might ask for permission to photograph the passage of the Communist troops from the boat's deck. It occurred to me to speak about it with the military attaché to Chiang Kai-shek, Colonel Guillermaz (future ambassador under Mao Zedong), who said to me: "I have no advice for you...but you might be better off not going." Words well taken: the Communists sank the boat.

I managed to keep photographing, as the Communists were allowing foreigners to continue working. I saw the great spectacle of the population of Nanjing—little shop-keepers and businessmen, full of traditional good humor—dazed and nervous with the arrival of this Spartan army of peasants from the North, on foot, crudely outfitted and not

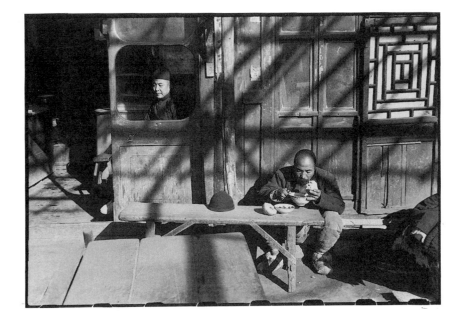

Last days of the Guomindang, Peking 1949

even speaking the same dialect. They were chanting their Three Commandments: 1) "Don't take even the needle and thread;" 2) "Think of the people as your family;" and 3) "You will give back everything that you have taken." People cheered for them, but with a certain unease, because in China soldiers had always been considered backwoods marauders, and so the army was looked down upon.

The frontiers were blocked, but a ship was sent to pick up any foreigners who wanted to get out of the country. As I was leaving, I had to show the censors my recent photographs. None of them raised any great objection. I set off then at the end of September 1949 for Shanghai, and arrived a few days later in Hong Kong. And there, after ten months, my first trip to China and its photographic journal ended.

1954

I was invited by Chinese Cultural Relations to come back and visit China again, from north to south and from the east to the west over several months, on the occasion of the tenth anniversary of the People's Republic. It was the so-called "Great Leap Forward," industrialization, catching up with England. You could have predicted the coming of the Cultural Revolution.

I was in Nanjing in 1949 when the Liberation Army arrived. At that time, I had the impression that those men were still holding on to the ideal of the prestige of that colossal epic, the Long March. Today, after Tiananmen Square, it is the great ignominy of the Chinese Army to have tried to save, with the blood of students, a dying regime.

1989

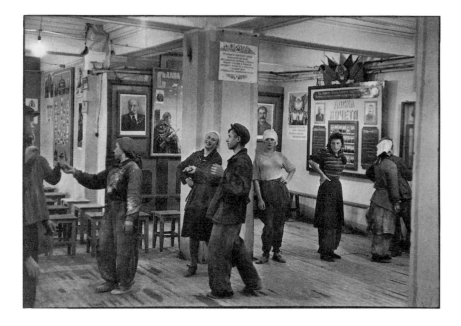

Cafeteria of the workers' building, Hotel Metropol, Moscow, 1954

THE PEOPLE OF MOSCOW

"There is a visa for you and your wife.

— When can we leave?

— As soon as you wish."

The news was too startling not to be a little upsetting. Nothing was really ready, though we had put in our visa applications eight months previously; waiting ever since, we had practically lost hope. Hope, though, had risen again two months before, when I learned that an album of my photographs, *The Decisive Moment—Images à la Sauvette*, which I had sent to Moscow to push my visa request, had been favorably received there.

As our passports were being stamped at the Consulate in Paris, I was told that my films would have to be developed over there, so I rushed to buy the chemicals I was used to; I rushed also to get a letter of credit from the *Office des Changes* and some Intourist cheques and our railway tickets.

Two days later, on July 8th, 1954, we were in the express train that was to take us straight to Prague. Neither my wife nor myself like to travel by air. You go too fast, you don't see the gradual changes that take place as you move from one

country to the next. I had not been in Czechoslovakia since 1930. We stayed overnight in Prague and the next morning we took possession of a sleeper on the Prague–Moscow express. It was all new to us, from the samovar at the end of the corridor, with its two attendants, to the green curtains in *velours frappé* (velvet damask) of which we were to see much later in Russia. The train sped through the whole length of Czechoslovakia and after one day we reached Tchop, the Russian border station.

This part of the trip lasted two and a half days in all, with the whole last day in Russia. When we arrived in Moscow, we felt a little like peasants in a large city, so great was the sensation of discovery. We wanted to see everything, know everything. I had never been in Russia before and was eager to start working at once. I was not sure, however, if I would have the facilities to photograph as freely as I am accustomed to elsewhere. In Paris, I had been told that a special permission was necessary to take pictures and I was afraid that, to secure it, I would have to enter into long explanations.

My photographs might have suffered from all this.

But in Moscow, I was told that foreigners could photograph everything freely with the exception of military objectives, railway centers, panoramic views of cities, and certain public monuments, for which an official authorization was required.

I was asked what we would like to see. I explained that my main interest was in people and that I would like to see them in the streets, in shops, at work, at play, in every visible aspect of daily life, wherever enough goes on so that I could approach them on tip-toes and take my photographs without disturbing them.

On that basis, we had laid out a plan. My photographic methods are not very common in Russia. Besides, neither my wife nor I speak Russian. We were given an interpreter. Every morning, he came to fetch us at our hotel and took us to wherever we wanted to go. Whenever we needed authorizations, he took care of the matter for us. He was very efficient and helpful. Often, in the street, people, startled by a foreigner bluntly snapping pictures right in their faces, came up to me. As I did not understand them, I stammered the only Russian sentence I had learned: "Tovarich perevodchik suda" (the comrade interpreter is back there). Then I would salute and proceed with my work, while the interpreter explained things. Soon, they stopped paying attention to me. In that manner, I was able to photograph a great many people, living and behaving just the way they would have if I had not been there. Before my trip to Moscow, I had already seen a large number of photographs of Soviet Russia. Yet my first reaction was one of surprise and discovery. I felt that, from my point of view, the subject was still fresh and almost

untouched—photographically speaking. So I tried to capture a straightforward image of the people of Moscow going about their daily life, to catch them in their ordinary acts and their human relationships. I fully realize how fragmentary that image is, but so much is certain: it represents my visual discovery faithfully.

Back in Paris, I was greatly interested by the questions we were asked. Some of them allowed us to see, as in a rear-viewer, the distance that lies between us and the country we had just left. At times, I could give no answer. Some people begin to ask: "How are things there, really?" and then, without giving me a chance to reply, go on to develop their own views. Others utter an "Oh, you just came back from there!" and shut themselves up in an embarrassed and wary silence—as people do at family meetings, when a particularly burning subject comes up. But to those who ask me, "What did you see?" I reply: "Let my eye speak for me." These pictures are meant for them.

<div align="right">1955</div>

P. S.
————

I am neither an economist nor a photographer of monuments, and even less a journalist. What I am looking for, above all else, is to be attentive to life.

Nineteen years after my first visit, I wanted to see the USSR again. Really, nothing is more revealing than to compare a country with itself, to grasp its changes, to try to catch the thread of its continuity.

The camera is not the right instrument to provide the whys and wherefores of things; it is, rather, designed to evoke, and in the best cases—in its own intuitive way—it asks questions and gives answers at the same time. I have thus used it in an active *flânerie*, in search of "objective chance."

1973

CUBA

As *Life* magazine was unable to send an American photographer to Cuba, they asked me to make the trip with my French passport, as they'd done when I traveled to China for the first time.

I'd met Nicolas Guillen, the great Cuban poet, in 1934, and when I learned that he had been appointed chargé of Cuban cultural relations, I let him know of my travel plans. He immediately said that I would be their guest, so I put my cards on the table and told him that I was doing a story for *Life*. He said: "Fine, but what would you like to do?" I said: "What I would really like is *not* to be with any delegates, but to stay in the old Hotel d'Angleterre—probably dilapidated—where Caruso stayed," etc. etc. "Fine. Anything else?" "I'd like you to provide an interpreter." "But you speak Spanish!" "Yes, but this way I'll be sure of my footing!"

And here is the little text that I wrote upon my return, in English, at *Life*'s request:

I am a visual man. I watch, watch, watch. I understand things through my eyes. This means I had to put Cuba—which I had not seen in thirty years—in the rangefinder of my mind,

so to speak, and correct for parallax so as not to get a false vision. You would get a wrong vision if you depended too much on the Cuban press. I could read their newspapers; I understand Spanish and speak it, except for mixing in Italian words and Mexican curses.

The press is full of propaganda and imprecations. The messages are crude and in a stereotyped Marxist lingo. And I could not ignore the posters that plaster the billboards and walls. A very few are good artistically, but even these advertise social and political ideas or boast of production figures instead of pushing usable goods. A popular one shouts, "A country that studies is a country that wins!"

But it is clear to me that many people are less confident than the slogans suggest. They know they are at the center of a fluid and very complex situation. They are struggling to industrialize and they are worried about the future. They live with the stern Marxist morality because they must, but they are allergic to organization and to the usual Communist emphasis on conformity of any kind.

Cuba is a pleasure island that has gone adrift, but it is still a Latin country, a tropical country, a country whose rhythm has an African beat. The people are easygoing and full of humor and kindness and grace, but also they have seen a lot and they are intuitively smart. Nobody will easily convert them into hard Communist zealots.

If they are a puzzle to the Western bloc, they are just as puzzling to the Communists. I was having my shoes shined and listening while the shoe-shine men talked. "Socialism?" said the shine man. "Certainly, I agree to go to the moon with the Russians. But down here—show me the good of Communism." I heard many such jokes during my stay.

Freedom of speech is something which nobody has yet killed in Cuba. One day I sat with a most important government official and, when conversation dwindled, he asked whether I knew the newest joke against the government.

"A high military commander," the official began, "was permitted to make a trip to the U.S. But the officer stayed away. Indeed, Fidel began to say, 'Just another traitor.' But at last he returned and reported to Fidel. 'Aha,' said Fidel, 'we all thought you had defected.' But the military man protested that he had been absent for so long only because it had been unavoidable. 'These Americans are so backward,' he said, patting his stomach, 'that they still eat the way we did three years ago.'"

One Sunday I visited a priest who is also a very good poet. I was looking over his recently published poems and was taken aback when some members of the state cinema board came to pay him a friendly visit—this in a country where, by Marxist belief, the priest should have been anathema. I was also surprised to find that *El Mundo* prints religious news.

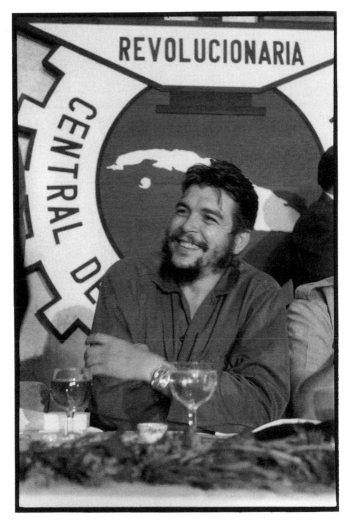

Che Guevara, Cuba, 1963

I was on the other side of the Bay of Havana, at a Yoruba voodoo ceremony, with a good friend who is a Cuban poet. Tacked to a tree was a government permit, complete with an official stamp. Just as the *diablito* was about to come out of the tabernacle, whipping branches about, and before the trance-dance, I asked for permission to photograph. I was told very politely: "During the week we are good Marxist-Leninists, but Sundays we keep for ourselves." I refrained.

The Cubans are doing a great deal of building but not the drab and dull utilitarian building of serious Communist countries. Here there is light and color, grace and imagination. Frank Lloyd Wright, Le Corbusier, and Louis Kahn could see themselves reflected in Cuba today.

The government seems to understand that some things about any absolute discipline do not fit the Cuban temperament. For example, nobody has tried to abridge that basic Cuban passion, the lottery. Instead, they have made it a tool of the revolution and have only reduced the prizes. The government simply takes a bigger percentage.

And, despite all the government talk about prohibiting ancient vices, prostitution has not been eradicated. Definite gestures to propriety have been made: the girls no longer roam the streets but conduct their business more discreetly. Some of the former girls have been persuaded to reform and

to enter an institution—I cannot recall the name, but it is something like "A Center for Artisans"—at Camagüey. I could not photograph there because, it was explained, some of the girls will certainly marry and it would of course be embarrassing for their husbands to see pictures suggesting their former professions.

I confess that I am French and I like to look at the ladies. I was much aware that Cuban women have curves but on the opposite end and the opposite side from where they are situated on, say, Miss Jayne Mansfield.

Since curves are curves and not politics, I sometimes made errors. One night I was walking along a hotel corridor with a friend. A beautiful young woman, in the room next to his, suddenly opened her door and popped out her head and other parts which might have given Miss Brigitte Bardot serious competition at St. Tropez. I asked who this might be. My friend answered stiffly, "She is in the Ministry of Industry."

I must have looked amused because he added, blushing, "Every night she studies Russian books on industrial planning."

Some things about Cuba did give me pause. There were, for example, the rifles. Cubans of the militia carry rifles the way a tourist carries a camera. Of the rifles I will only say that when I must walk around a horse, I walk around the

front end. And when I walk around a rifle, I walk around the back end.

There is one matter which upset me most deeply—the Committee for the Defense of the Revolution. Obviously they do social work and do a great deal of it. They distribute clothing, give vaccinations, fight juvenile delinquency. They do much good. But also they know exactly what is going on in every family in every block. This, to my feeling, is pernicious, an invasion of privacy at best, the beginning of thought control and witch hunting at worst.

I kept asking to meet Fidel—nobody calls him Castro, only Fidel. Everybody tried to help me, but it was a problem because Castro still lives like the hit-and-run man of the hills.

While waiting I went on with my work, including portraits of Fidel's right-hand man, Che Guevara, who is much more than his title of Minister of Industries. To the camera as elsewhere, Che is a violent man but a realist. His eyes glow; they coax, entice and mesmerize. This is a persuasive man and a true anarchist, but he is no martyr. One feels that if the revolution in Cuba should break up, Che would appear elsewhere in Latin America, very much alive and throwing bombs.

In the end I did see Fidel. A car came for me, a Cadillac so full of machine guns on the floor in back that my knees were doubled under my chin. I met Fidel backstage at the

Chaplin Theater where he was to make a speech. This man is both a messiah and a potential martyr. Unlike Che, I think he would prefer to die rather than see the revolution disappear. Also he is the respected boss; there is no question of that. His men laugh and joke among themselves until he comes in and then, you feel it and see it: the leader is there.

I think you could say of Fidel that his whiskers form a nest for the disinherited. Marxism he speaks aloud—but that is in the head, not in the beard or in the voice. He has the neck of a minotaur, the conviction of a messiah. There is a powerful magnetism about him; in a way he is a force of nature. He makes people sing and sway together and carries them with him. I observed, being a Frenchman, that after three hours of speaking, the women in his presence still tremble with ecstasy. But I must say also that in three hours he puts the men to sleep.

1963

III

On Photographers
and Friends

Si, en faisant un portrait
on espère saisir le silence
intérieur d'une victime
consentante, il est Très
difficile de lui introduire
entre la chemise et la
peau un appareil photo-
graphique.
 Quant au portrait au
crayon, c'est au dessina-
teur d'avoir un silence
intérieur —

18.1.1996

IF, IN MAKING A PORTRAIT, you hope to grasp the interior silence of a willing victim, it's very difficult, but you must somehow position the camera between his shirt and his skin.

Whereas with pencil drawing, it is up to the artist to have an interior silence.

1996

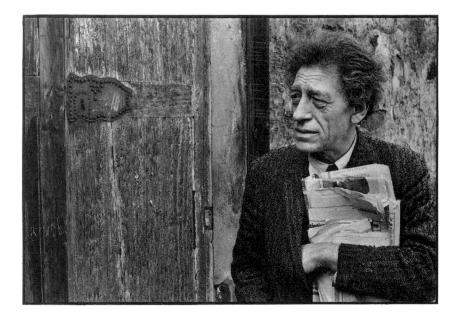

Alberto Giacometti, 1961

FOR ALBERTO GIACOMETTI

The expression hardly changes on that craggy face; the mask surprises you: you're never quite sure whether he has heard you. But his responses! Always right on the mark, profound, and personal, on the most varied subjects.

Giacometti is one of the most intelligent and lucid men I know, honest with himself and harsh with his own work, digging right in where things are most difficult. In Paris, he gets up at about three o'clock in the afternoon, goes to the corner café, works, rambles over to Montparnasse, and goes to bed at daylight. Annette is his wife.

Giacometti's fingernails are always black; but he isn't sloppy or in the least bit affected. He hardly ever speaks about sculpture with other sculptors, unless it's with Pierre Josse, one of his childhood friends, a banker and sculptor, or with Diego, his own brother. I was overjoyed to learn that Alberto had the same three passions that I have: Cézanne, Van Eyck, and Uccello. He has said things that are so right about photography and the attitude one needs to have, and also about color photography.

Of Cézanne and the other two, he once said admiringly: "They are monsters." His face has the look of a sculpture—

not one of his own—except for that furrow of wrinkles. His gait, the way he moves, is very distinct: one heel set far ahead—perhaps he's had some accident, I don't know. But the movement of his thinking is even more particular: his answer goes far beyond what you have said; he draws a line, adds everything up and starts another equation altogether. Such vibrancy of spirit: the least conventional, the most honest.

In the town of Stampa, in the Swiss Graubünden canton, three or four kilometers from Italy, is his mother's house; she is ninety years old, alive and intelligent, and she knows how to make her son stop working on a painting she likes, if she feels it's finished. His father's studio is an old barn. Alberto works there in the summertime; in the winter he shuts himself up in the dining room. Either he or his brother Diego calls their mother every day from Paris. Diego is extremely modest, and very reserved. Alberto greatly admires his brother's talent as a sculptor; Diego makes beautiful furniture and casts Alberto's sculptures. More than once, Alberto has said to me: "The real sculptor isn't me, it's Diego."

The house where his father was born is now the village inn—it belongs to his cousin; the grocery store is owned by another cousin. When he asks the price of the apples he is buying in order to paint them, she says: "Well, that depends on how much you'll get for your painting!" Alberto has told

me that he used to get bored, and would try to do too much at one time—apples, landscapes, portraits—and that he had to concentrate on just two subjects. It's marvelous, such a sense of economy, which is the measure of taste.

The openings for his exhibitions are grand events, but for him they are a sore subject. He says: "I should just bring out everything I have at a given date and show it, and say, 'This is where I am right now.'" Again, such honesty. But no matter what he says, his work comes off as being hand-in-glove with beauty itself.

For Alberto, intellect is an instrument at the service of sensitivity. In certain areas, however, his sensitivity takes odd forms; for example, his deep scorn for all emotional sloppiness.

But enough: he's my friend.

ERNST HAAS

For me Ernst was sensitivity itself; he had an irresistible charm and wit, a knowledge of the world, its color, its *stratis ficatious* since its origin, various cultures he expressed so vividly in his photographs.

He disappeared swiftly like a comet leaving behind a long trail of human understanding and with such finesse.

I can hear him bursting out laughing and making fun of me if he had read this.

1986

ROMEO MARTINEZ

———

Romeo Martinez is, in my humble opinion, the father confessor to a number of photographers who come to him to beg for absolution.

His own great sin is never to have asked what the alms are for this parish that he has brought to photography.

He knows more about each of us than we ourselves do.

1983

ROBERT DOISNEAU

———

Our friendship is lost in the darkness of time. We will no longer have his laugh, full of compassion, nor his hard-hitting retorts, so funny and profound. Never told twice: each time a surprise. But his deep kindness, his love for all beings and for a simple life will always exist in his work.

1994

SARAH MOON

—————

Question mark? That's the title Sarah Moon chose for this documentary, which has nothing conventional about it, from which I am constantly trying to escape, and in which she keeps catching me.... Several times in the film, I ask myself the question: "What is this about?" In the end, there are no answers. In photography, as elsewhere, the instant is its own question and at the same time its own answer. What excites and drives me in photography is the coincidence of gesture and spirit. There is no duality, nor are there rules.

Sarah Moon came along without any preconceived notion, diaphanous, translucent, with her little home-video camera—and had to face me, bad dog that I am, who thrashed about like the devil in a baptismal font. She let me say whatever I had to say, in spite of my constant non sequiturs. She wove together and balanced the three activities that absorb me: drawing, photography, and documentary film. But from only one angle. Sarah Moon did not attempt to give more weight to photography, for which I'm obviously not unknown. My notoriety is a heavy load: I refuse to be a standard-bearer; I have spent my whole life trying to be inconspicuous in order to observe better.

The segregation of photography, the ghetto into which this world of specialists has placed it, really shocks me. Photographers, artists, sculptors.... You either have a feel for the plastic, or else a conceptual thought. Some people prefer one over the other; that's not my problem. My problem is to be in my life. To seize the moment in its fullness. Thought alone doesn't interest me. Photography is a manual labor: you have to move, to shift.... The body and the spirit should add up to one only. An aside: despite the inconvenience, it was useful for a young surrealizing bourgeois, during the three years of his captivity, to do some manual labor—pounding in railroad cross-ties, working in cemeteries and auto factories, washing grub in huge copper cauldrons, making hay. And all the time with one idea in mind: escape. Sarah Moon understood that. I have seen her film several times, but—doubtless because of her subtlety—I still can't see what it has to do with me. What good luck!

ROBERT CAPA

———

For me, Capa wore the dazzling matador's costume, but he never went in for the kill; a great player, he fought generously for himself and for others in a whirlwind. Destiny was determined that he should be struck down at the height of his glory.

1996

TÉRIADE

———

—Velvet glove and fervor.

—Eye of lynx and lively pen, which since 1926 has revealed his perspicacity on Art and our epoch.

—Intense flair, from an ancient culture.

But what good is it to say all this?

—The word *verve* is creative fantasy, and his "VERVE" describes him superbly and forever.

1997

Each time André Kertész's
shutter clicks I feel his heart
beating; in the twinkle
of his eye I see Pythagore's
sparkle.
All this in an admirable
continuity of curiosity.

3.1984

JEAN RENOIR

In 1936, as a kind of sales rep presenting my catalog, I showed him a collection of some forty of my photographs, printed with extreme care, and asked him if he might need an assistant. I had just received a negative response from Luis Buñuel, whom I had known well during the Surrealist era.

Jean hired me, along with several others, to work on the shooting of *La vie est à nous* (Life is ours), a sort of messy and guileless whirlwind, which stirred up enthusiasm for the Popular Front. He hired me again as second assistant on *Une partie de campagne* (A day in the country); Jacques Becker was the first assistant, and Luchino Visconti was there as an observer.

In the United States, "assistant" was an entirely different profession; with us it was a stepping stone en route to becoming a director. But Jean realized early on (as did I) that I was never going to be a director. Because a great director must treat time as a novelist would, while the metier of a photojournalist is closer to a documentary filmmaker.

The second assistant is a sort of Gal Friday: I had to look for a junk-shop music-box to accompany the scene of Sylvia

Bataille's seduction; and for *La regle du jeu* (The rules of the game), I had to come up with the castle in Sologne, and teach Dalio how to handle a shotgun. . . .

But my real passion was working on scripts: finding the precise word in a kind of jam-session, which sometimes took place in the morning, just before we started shooting. Jean was an overflowing river of *joie de vivre*, of refinement: he was intensity itself. "Becker and Cartier, you speak '*The The*,'" he says to us one day to make us understand that we were falling under the influence of English, while he affected a working-class accent. You felt his fondness for the people he worked with; the little roles were as important as the big ones. He detested the "Actor's studio" school of thought—that tiresome and pedantic world was really the opposite of his style. Instead, he adored actors who came out of music-halls, who had only one or two acts with which to seduce their public.

But Jean wasn't a fighter: like a big animal grappling with pesky mosquitoes and flies, he snapped energetically. It was up to his assistants to know when to propose a ballgame or when to go fetch a bottle of Beaujolais or when to bring over one of his friends, such as Pierre Lestringuez. Jean also wanted his assistants to take on little roles as extras in the films, so that they could understand what people went through on the other side of the camera. And so, with Pierre Lestringuez as father superior, the dutiful seminarians—

among them Georges Bataille and myself—were led on parade; me with my mouth hanging open at the discovery of Sylvia Bataille's frilly underclothes hanging on a swing.

We ran into difficulties during the shooting of *Une partie de campagne* due to the rain; we took shelter in Jean's villa at Marlotte, where there were a lot of empty frames—the father's works having served to finance those of the son. As for *La règle du jeu*, that prodigious film had something prophetic about it, on the eve of the war; the drama in that castle was played out in Jean's real life as well—very discreetly, but you can sense these things. Marguerite, his editor, whom Becker and I called "the little lion," had been his companion for years; and while making that film he hired Dido, whom he would marry by the next. The prewar public did not get the juxtaposition of comic and tragic, and the total failure of the film was a deep wound for Jean. After that, he went off to shoot *Tosca* in Italy, with Karl Koch as assistant.

Much later, I ran into Jean and Dido in Hollywood, where they often saw Jean Gabin, Antoine de Saint-Exupéry, the composer Hans Ersler, and Jean's father's old model Gabrielle. Next there was to be a film project in France with Jeanne Moreau, but the producers—the cowards—were afraid that he wouldn't be able to finish shooting; finally, Truffaut, Rivette, and Rossellini had to guarantee that they would finish the film if anything happened to Jean.

One day in 1975, I received an affectionate letter from him, in which he gave me a reason to give up photography. Later, sorting out my mail, I tore up the envelope and just kept the letter. The following day I learned of his death, but his vibrant laugh, his caustic tone, and his very musical voice still resound in me.

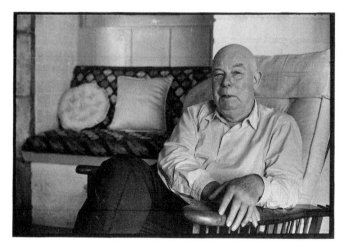

Jean Renoir, 1967

MY FRIEND CHIM
[David Seymour]

————

Chim, like Robert Capa, was a Parisian from Montparnasse. He had the intelligence of a chess player; with the air of a math teacher he applied his vast curiosity and culture to a great number of subjects.

We had been friends since 1933. The precision of his critical spirit had rapidly become indispensable to those around him. Photography to him was a pawn that he moved all over the chessboard of his intelligence. One of his pawns kept in reserve was his culinary delicacy, which he handled with gentle authority, always ordering good wines and elaborate dishes. He had one area of personal elegance: his black silk ties.

His perspicacity, his very delicacy, often gave him a sad, even disabused smile, which brightened if one humored him. He gave and demanded much human warmth. He had so many friends everywhere; he was a born godfather.

When I went to announce his death to his friend Dave Schoenbrun, he said to me in the conversation that followed: "You and I know each other very little. And yet

Chim was a friend of both of us. He was a man of secret compartments and forgot to make them communicate."

He accepted the servitudes of his profession, and turned out to be brave in situations that seemed utterly foreign to his personality. Chim picked up his camera the way a doctor takes his stethoscope out of his bag, applying his diagnosis to the condition of the heart. His own was vulnerable.

1996

André Breton, 1961

ANDRÉ BRETON: SUN KING

I

I have probably known him since about 1928 or 1929. I was once a diligent presence, sitting at one end of the table, at the Surrealists' meetings at the café on the Place Blanche, too shy and too young to say a word. I had hardly seen him since the War—having lived in Asia and elsewhere—but I found his studio just I had known it before: a hodgepodge of fantastic amulets. He was as intimidating as the Sun King, but he was just as intimidated as I was; there was an onslaught of politenesses and compliments, but you never knew if, without prior warning, he might become angry and excommunicate you. That said, the gentleman always possessed a deep dignity and great probity. His wife, charming and Chilean, disappeared when he was there—willingly, I believe.

With great ceremony, he went down the three steep flights of stairs to go outside and fetch some wonderful ice-cream for my sister, who had accompanied me. He wore a salmon-colored shirt. He watched me attentively when I talked, but never completely gave away his own thought.

The next day, I was at the Promenade de Vénus, where he saw his young initiates—just like me in my youth, except that this café was at Les Halles. A newspaper vendor went by shouting the headline: "Debré Launches the Breton Plan." A Surrealist moment, made to order! Everybody laughed; he remained impassive. (For those of you who don't know, it was actually a story about people from Bretagne.)

It's odd, there was nothing effeminate about him, with his lion's mane and his head always held high, but still there was something a bit feminine—maybe it was his wide buttocks. I recall that Dalí said of him: "I had a dream in which I slept with Breton," and Breton, tremendously dignified, shot back: "I wouldn't advise you to try it, my dear."

The anecdotes about him are innumerable; but beyond the anecdotes, I owe an allegiance to Surrealism, because it taught me to let the photographic lens look into the rubble of the unconscious and of chance.

II
—————

Saint-Cirq-Lapopie, a medieval village built on the cliff above the Lot River.

Breton goes through town one evening on his way to have a glass of white wine at the inn. His mane is brushed back as on a magus from olden times, his head is held high

above the crowds of tourist-pilgrims and their 404s and *deux chevaux*, but he nods to the locals of his acquaintance.

With me, he is always both amicable and respectful, but gripped by a tight smile that becomes somewhat pained as soon as I take out my camera. In the end, it was an excellent exercise for me to come home with no more than a dozen photographs, only six of which were usable. And how many impossible photos had to remain in my eyes—reading Hugo, Lequier, and Baudelaire, which he would do with his wife and three young Surrealists-in-progress—the eye as lighthouse in a storm. That place was full of their breath: primitive paintings on the wall, a Henri III buffet, showcases of butterflies, gothic windows. The rock garden was very tidy. Breton's passion: to look in the Lot for agate—an esoteric quest, as he told me. We were twice together; even at twenty meters' distance from him, and even with the current's babbling, he heard the click of my Leica and made a signal to me with his finger like an indulgent professor: "You're starting up again!"—and at the same time with the other hand, I kept burrowing in the pebbles under my feet. You knew where to find second-rate and second-hand agates: in the shrub-boxes on the terrace of the café where Breton, upon his return, would dump his surplus.

Under the arbor of the little restaurant in the village, one eats at a fixed hour. Breton is very exacting about his

meals; he promptly greets the other guests who come to eat, but does so with a slight edge of irritation to the "*Bon appétit*" which closes the greeting. It is difficult for him to hide his irritation; the banality of their conversations reaches him from the neighboring tables. He takes up his diatribes against Cézanne and others ("*You* love Cézanne!" he accuses, pointing an inquisitor's finger across the table in the direction of my nose). His attacks are generally based on moral principles. He loathes Italy (except for Uccello). The attacks are founded on people's moral stance.

Breton is an upstanding gentleman, extremely polite and a bit stiff, a sovereign pundit—badmouths might even call him a pontificator. Maybe it is a modest shyness? One never knows whether, after saying politely to you: "*You* love such and such, . . ." he might launch into imprecations or throw some condemnation at you, which will force you to question yourself.

SAM SZAFRAN

———

Sam—I owe him a lot; he is one of those very rare people, along with Tériade, who some twenty-five years ago encouraged me to quit playing the same old instrument forever.

To those who were surprised that I abandoned photography, he says: "Let him draw if that's what he likes, and anyway, he never stopped taking photographs, only now it isn't with a camera but mentally."

I wouldn't try to talk about his work, as I am still no expert-witness Art critic.

I would say first of all that Sam continues to speak well of people with whom he has quarreled. Sam's thinking is very particular, strict, and as poignant as the strike of a sword. His conversation is surprising: fed by his experiences, never by small talk or chitchat.

Sam to me is an acrobatic intelligence, a heart in fusion, a dazzling senselessness.

That said, with crayon or charcoal in hand, he's like a clavier, well-tempered.

His brotherly friend, Henri

1995

GEORG EISLER

—a whirlwind of indefatigable generosity

—an ever-present pencil, on the alert for sensations

—a subtle color

—an unfailing kindness

—etc.... etc.... etc....

1996

Georg ?

— un Tourbillon
de générosité
infatigable
— un crayon toujours
présent épiant tes sensa-
tions. -
— une couleur
subtile
— une amitié sans
faille
— etc.... etc... etc...

Henri

3.10.96

Messieurs

J'ai bien reçu l'acte II scène II, que vous avez bien voulu m'adresser sur "l'Acte Photographique".

Profondément ému, je tiens a vous dire combien je suis sensible au dévouement que vous consacrez a l' acte de notre grand doigt masturbateur d'obturateurs lié a l'agent perturbateur qu' est notre organe visuel (voir la dioptrique du "Discours de la Méthode" de Descartes).

Avec tous mes remerciements, avant de prendre mes jambes de reporter a mon cou, je vous prie d'accepter l'hommage d'un photographe repentant

Henri Cartier-Bresson

104

SIRS,

I have received Act II, Scene II of "L'Acte Photographique," which you were kind enough to send me.

I am deeply moved, and feel I must tell you how sensitive I am to your devotion to the action of our great masturbatory finger on the shutter connected to the subversive agent that is our visual organ (see the dioptric of Descartes's "Discourse on Method").

With many thanks, before I take to my heels, I beg you to accept the respects of this repentant photographer.

1982

ACKNOWLEDGEMENTS
AND BIBLIOGRAPHY

———

The author wishes to thank Marie-Thérèse Dumas, who knows his scraps of paper better than he does himself, and to express his gratitude to Martine Franck, Gérard Macé, and Bruno Roy.

English translation of essays on pages 4, 8–11, 16 (last two paragraphs), 19, 20 (quote), 43 (postscript), 46, 51–61, 66–67 (postscript), 79, 81–83, 85–87, 88 (bottom), 90–93, 97–102, 105 by Diana C. Stoll.

Texts in this book were published in the following volumes:

Images à la sauvette, Verve, 1952, cover by Henri Matisse.

The Decisive Moment, Simon and Schuster, 1952.

L'Imaginaire d'après nature, Paris: Delpire, Nouvel Observateur, 1976.

L'Imaginaire d'après nature, Saint Clément: Fata Morgana, 1996.

Les Européens, Paris: Verve, 1955, cover by Joan Miró.

Europeans, New York: Bullfinch, 1998.

Moscou, 1955, Paris: Delpire, Collection Neuf, 1955.

Moscou, 1955, "A propos de l'URSS." Paris: Chêne, 1973.

The People of Moscow, New York: Simon and Schuster, 1955.

"Cuba." *Life* magazine 54 (11): 28–43 (1963).

André Breton, roi soleil, Saint Clément: Fata Morgana, Hôtel du grand miroir, 1995.

The letter reproduced on page 104 is a response to the invitation from the *Cahiers de la photographie* to the Sorbonne colloquium, organized under their auspices in November 1982, on the theme of "The Photographic Act." It was published in *Le Monde*, December 17, 1982.

Library of Congress Catalog Card Number: 99-64610
Hardcover ISBN: 0-89381-875-5
Limited Edition ISBN: 0-89381-890-9

Book design by Amy Henderson
Jacket design by Michelle M. Dunn

Printed and bound by RR Donnelley & Sons Company

The Staff at Aperture for *The Mind's Eye* is:
Michael E. Hoffman, Executive Director
Michael L. Sand, Editor
Stevan A. Baron, Production Director
Eileen Max, Associate Production Director
Lesley A. Martin, Managing Editor
Laurel Ptak, Assistant Editor
Elaine Schnoor, Production Work-Scholar

First edition
10 9 8 7 6 5 4 3 2 1

Aperture Foundation publishes a periodical, books, portfolios of fine photography and presents world-class exhibitions to communicate with serious photographers and creative people everywhere. Catalogs are available upon request.

Aperture Book Center and Customer Service, Millerton. P.O. Box M, Millerton, NY 12546. Phone: (518) 789-9003. Fax: (518) 789-3394. Toll-free: (800) 929-2323. E-mail: customerservice@aperture.org

Aperture Foundation, including bookstore and Burden Gallery, New York. 20 East 23rd Street, New York, New York 10010. Phone: (212) 505-5555, ext. 300. Fax: (212) 979-7759. E-mail: info@aperture.org

Visit the Aperture website at http://www.aperture.org

Aperture Foundation books are distributed internationally through: **Canada:** General/Irwin Publishing Co., Ltd., 325 Humber College Blvd., Etobicoke, Ontario, M9W 7C3, Fax: (416) 213-1917. **United Kingdom, Scandinavia, and Continental Europe:** Robert Hale, Ltd., Clerkenwell House, 45-47 Clerkenwell Green, London, United Kingdom, EC1R OHT, Fax: (44) 171-490-4958. **Netherlands, Belgium, Luxemburg:** Nilsson & Lamm, BV, Pampuslaan 212-214, P.O. Box 195, 1382 JS Weesp, Fax: (31) 29-441-5054. **Australia:** Tower Books Pty. Ltd., Unit 9/19 Rodborough Road, Frenchs Forest, Sydney, New South Wales, Australia, Fax: (61) 2-9975-5599. **New Zealand:** Southern Publishers Group, 22 Burleigh Street, Grafton, Auckland, New Zealand, Fax: (64) 9-309-6170. **India:** TBI Publishers, 46, Housing Project, South Extension Part-I, New Delhi 110049, India, Fax: (91) 11-461-0576

For international magazine subscription orders to the periodical *Aperture*, contact Aperture International Subscription Service, P.O. Box 14, Harold Hill, Romford, RM3 8EQ, United Kingdom. One year: $50.00. Price subject to change.

To subscribe to the periodical *Aperture* in the U.S.A. write Aperture, P.O. Box 3000, Denville, New Jersey 07834. Toll-free: (800) 783-4903. One year: $40.00. Two years: $66.00.

A limited edition of *The Mind's Eye*, signed and numbered by Henri Cartier-Bresson, is available exclusively through Aperture. Each limited edition is accompanied by an original eight-by-ten-inch gelatin-silver print of Martine Franck's portrait of Cartier-Bresson (back of book jacket), signed and numbered by Martine Franck. The edition is limited to 100 numbered copies and fifteen artist's proofs.

For further information about this and other limited editions, contact Aperture's Burden Gallery, 20 East 23rd Street, New York, New York 10010. Phone: (212) 505-5555, ext. 325. Fax: (212) 979-7759. E-Mail: gallery@aperture.org